MER-GATROID

DRAW IN THIS BOOK

© Elaina L. Buie 2010

published by Elaina L. Buie
through LuLu.com

I highly recommend drawing in this book while listening to SHUGO TOKUMARU's album, "EXIT"

ISBN 978-0-557-95669-2

Dance with me and my pet Tiger.
He bites.

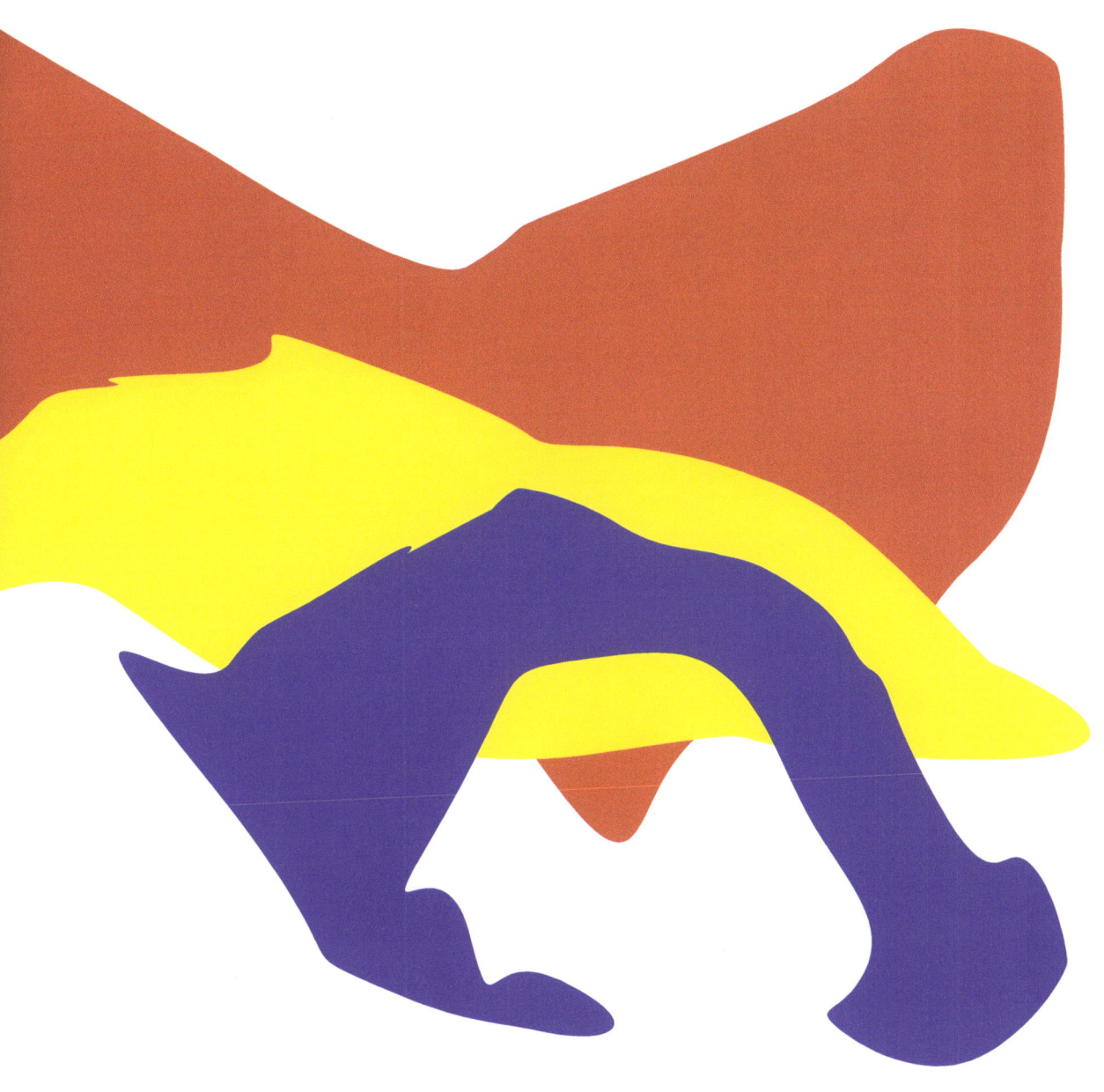

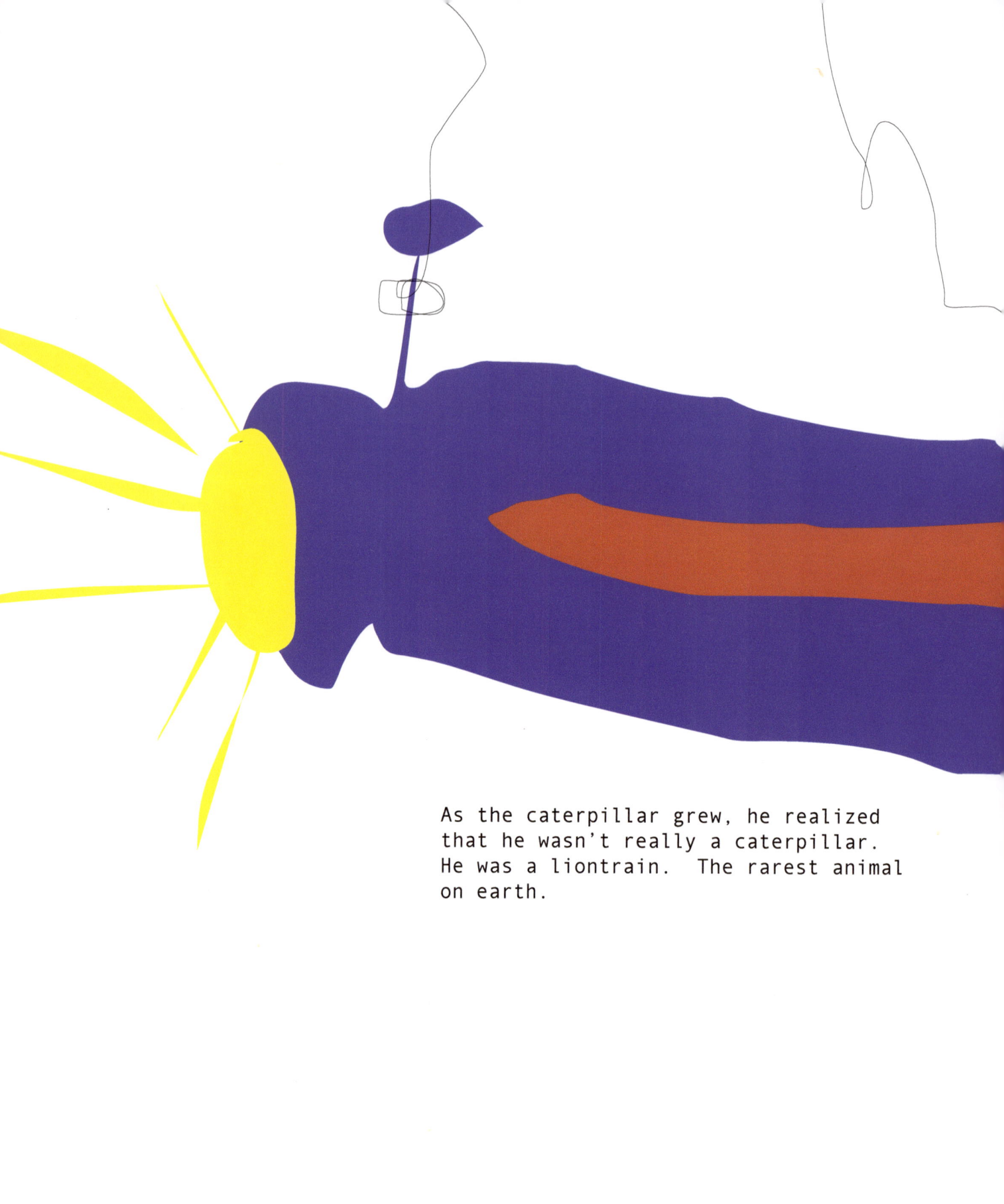

As the caterpillar grew, he realized that he wasn't really a caterpillar. He was a liontrain. The rarest animal on earth.

```
HOW?   How?, he asked.   How could this happen?
It's only because Oprah's show is going off the air.   That's why.
```

look

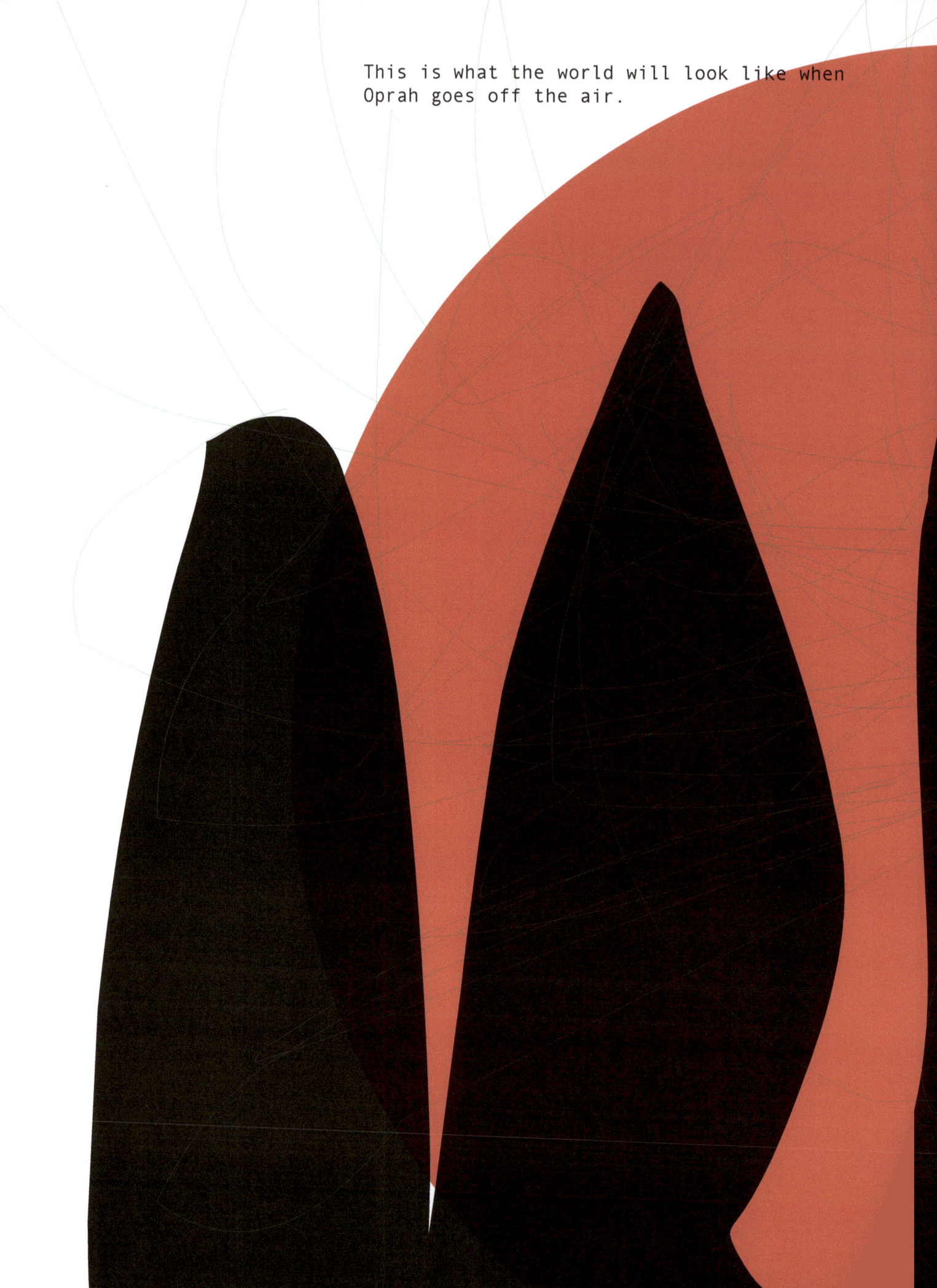

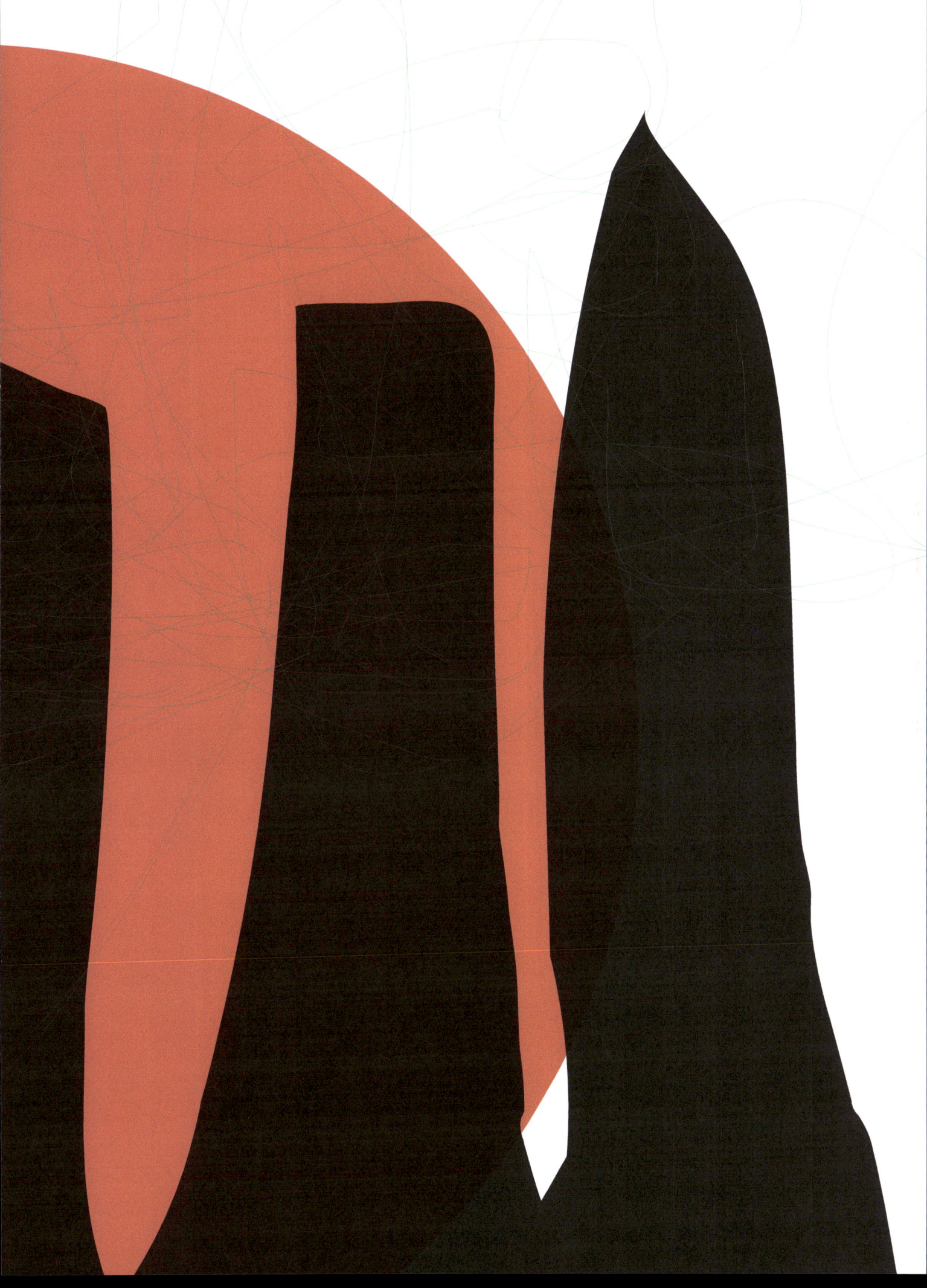

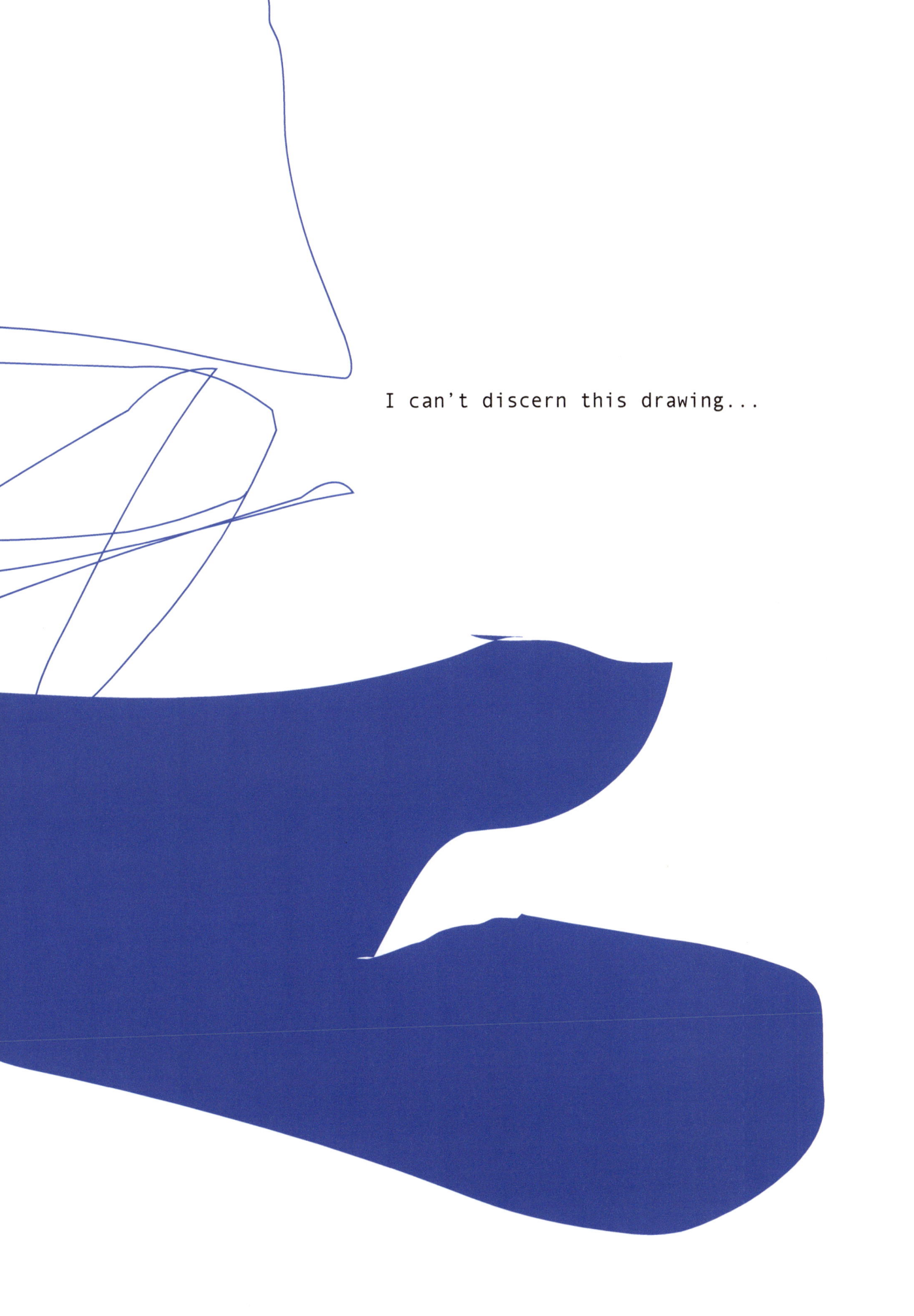

I can't discern this drawing...

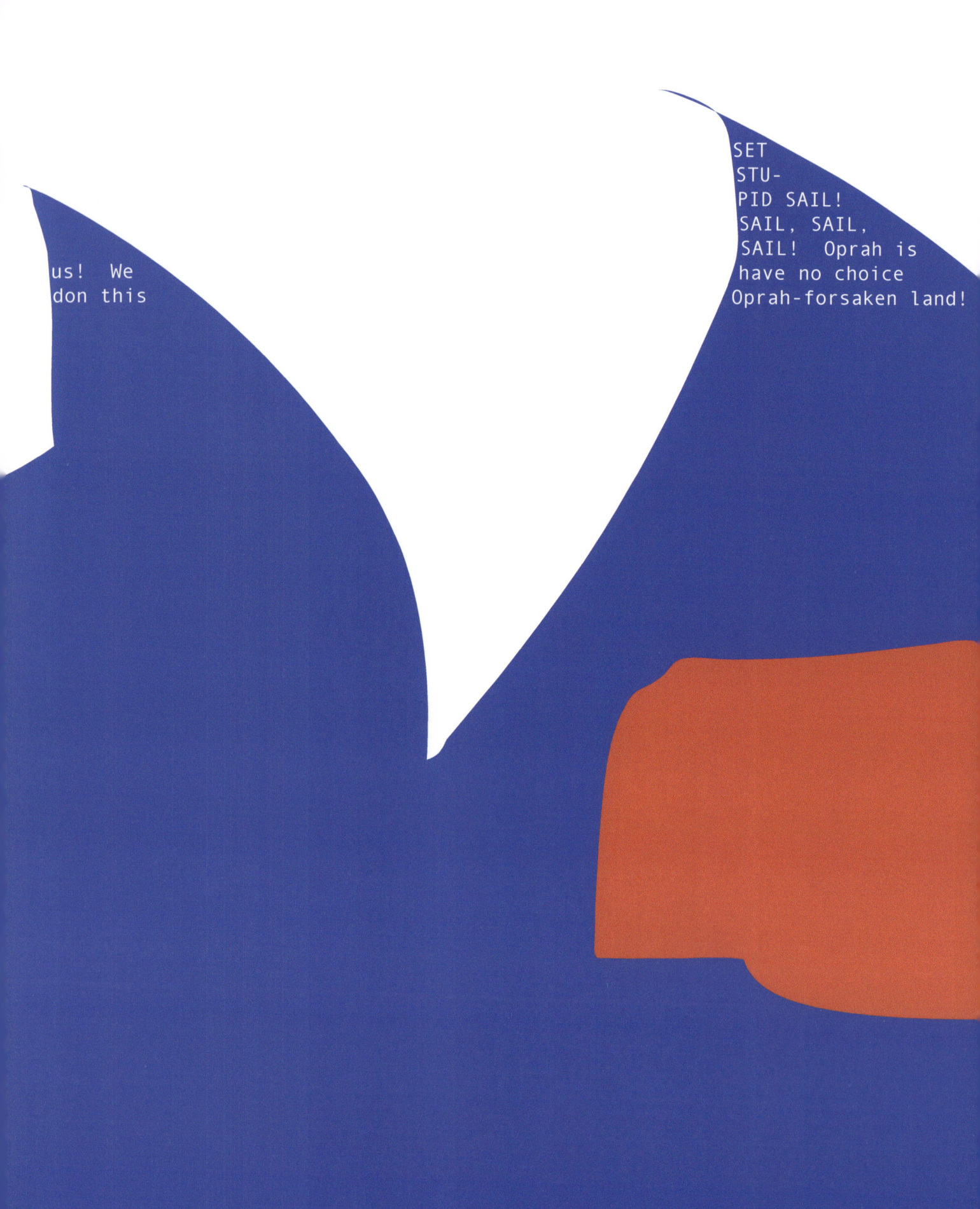

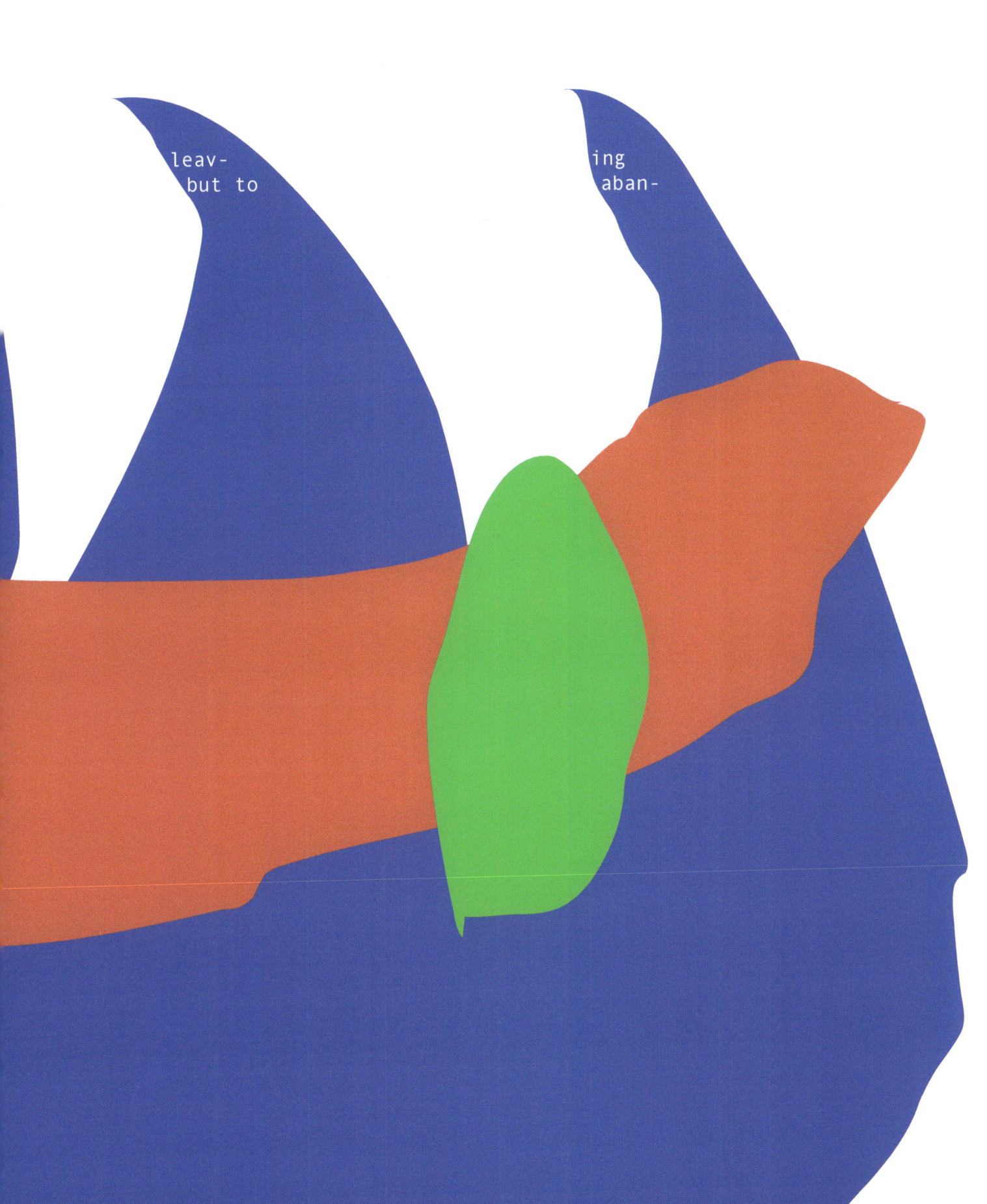

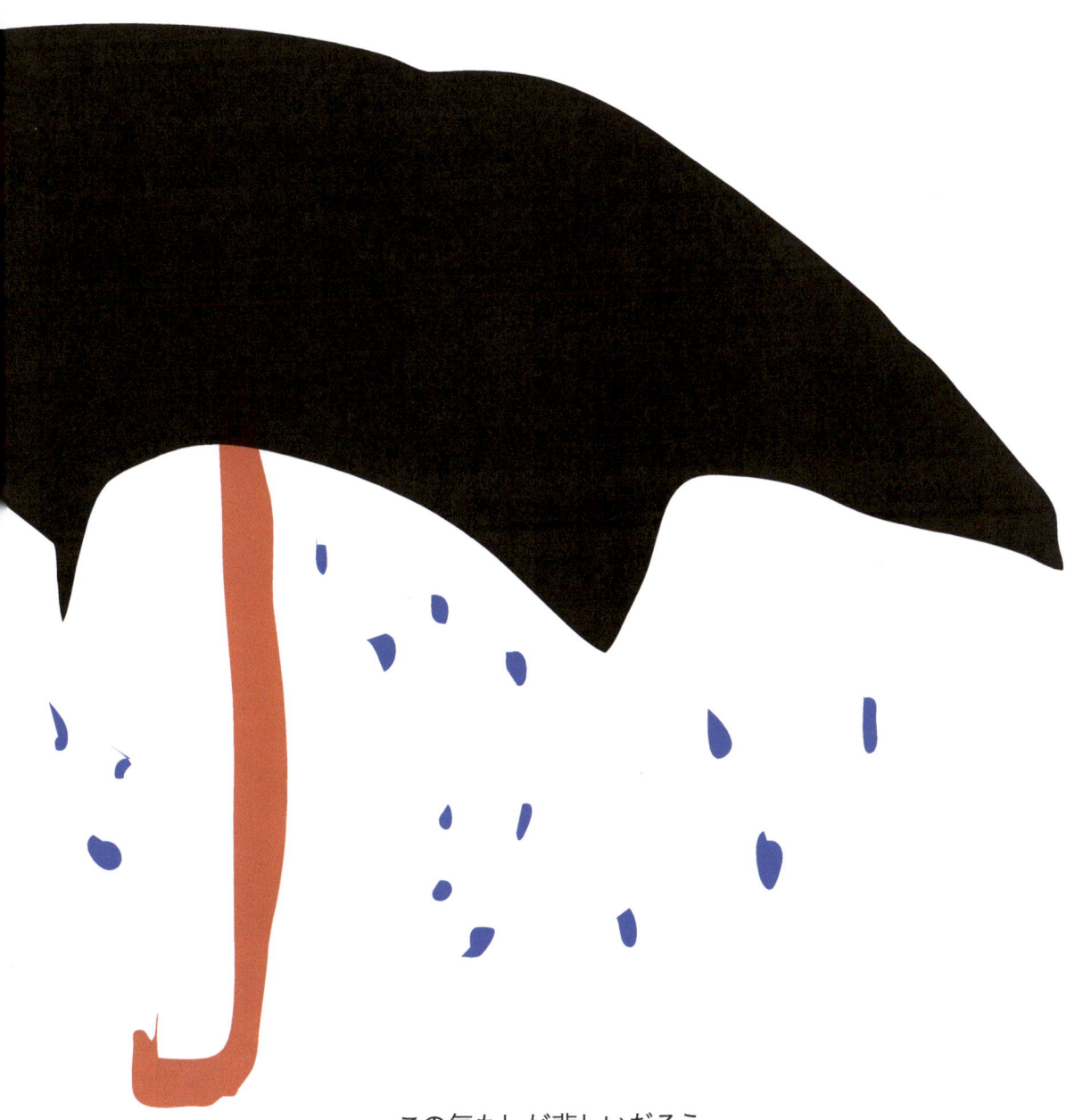

この気もしが悲しいだろう。

Life Is Grand! Life Is Grand!

"Why do you make art like this? Shouldn't you try to be more mature?"

Maybe. But I'm not. I like making messes, drawing with markers, setting things on fire, etc. I'd say that's not mature. But that's the way God made me. I'm mature when I need to be. But when it comes to drawing, it's not something so serious that needs my maturity.

"It's just drawing, but I like it!"
Yoshitomo Nara

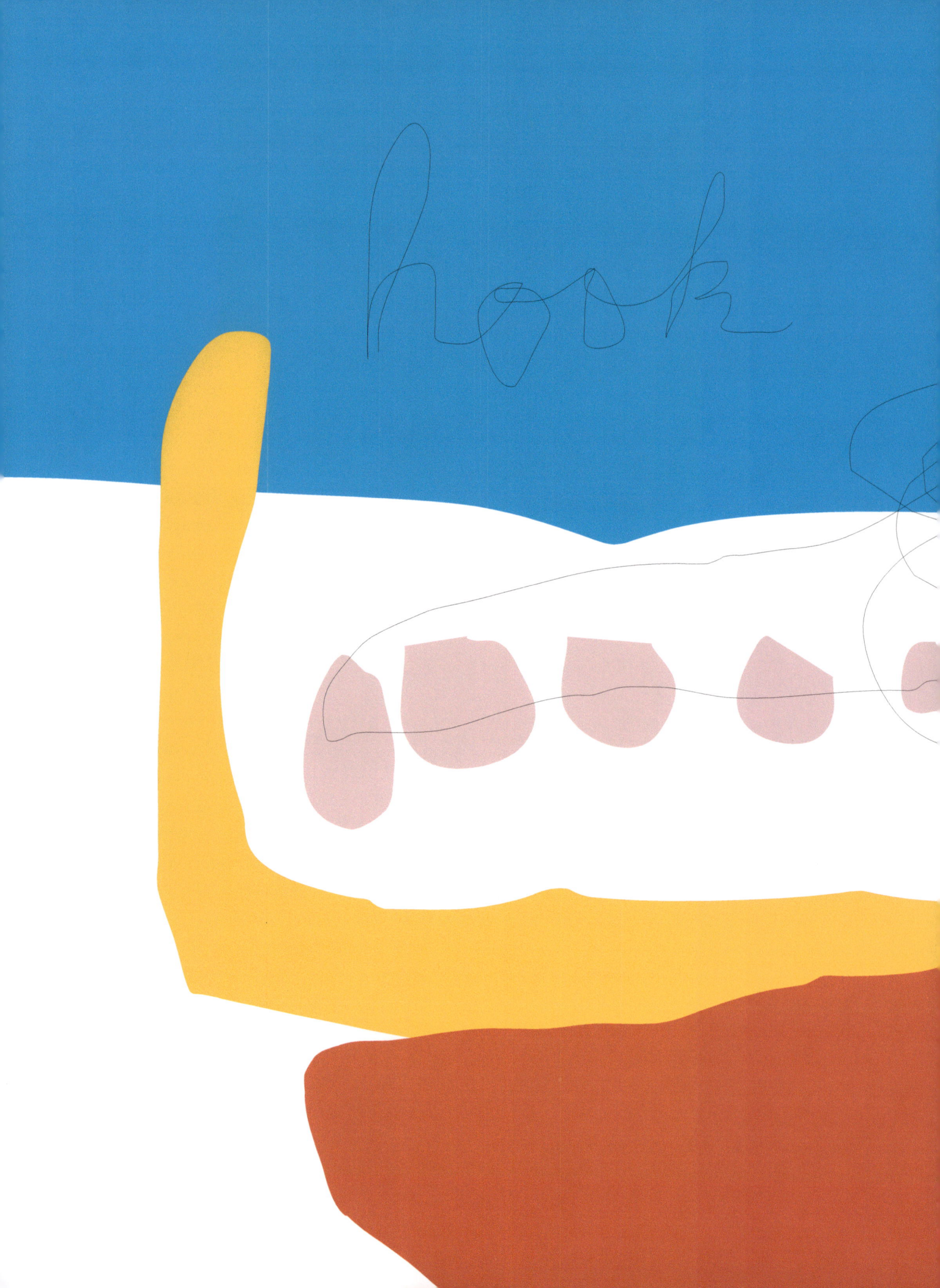

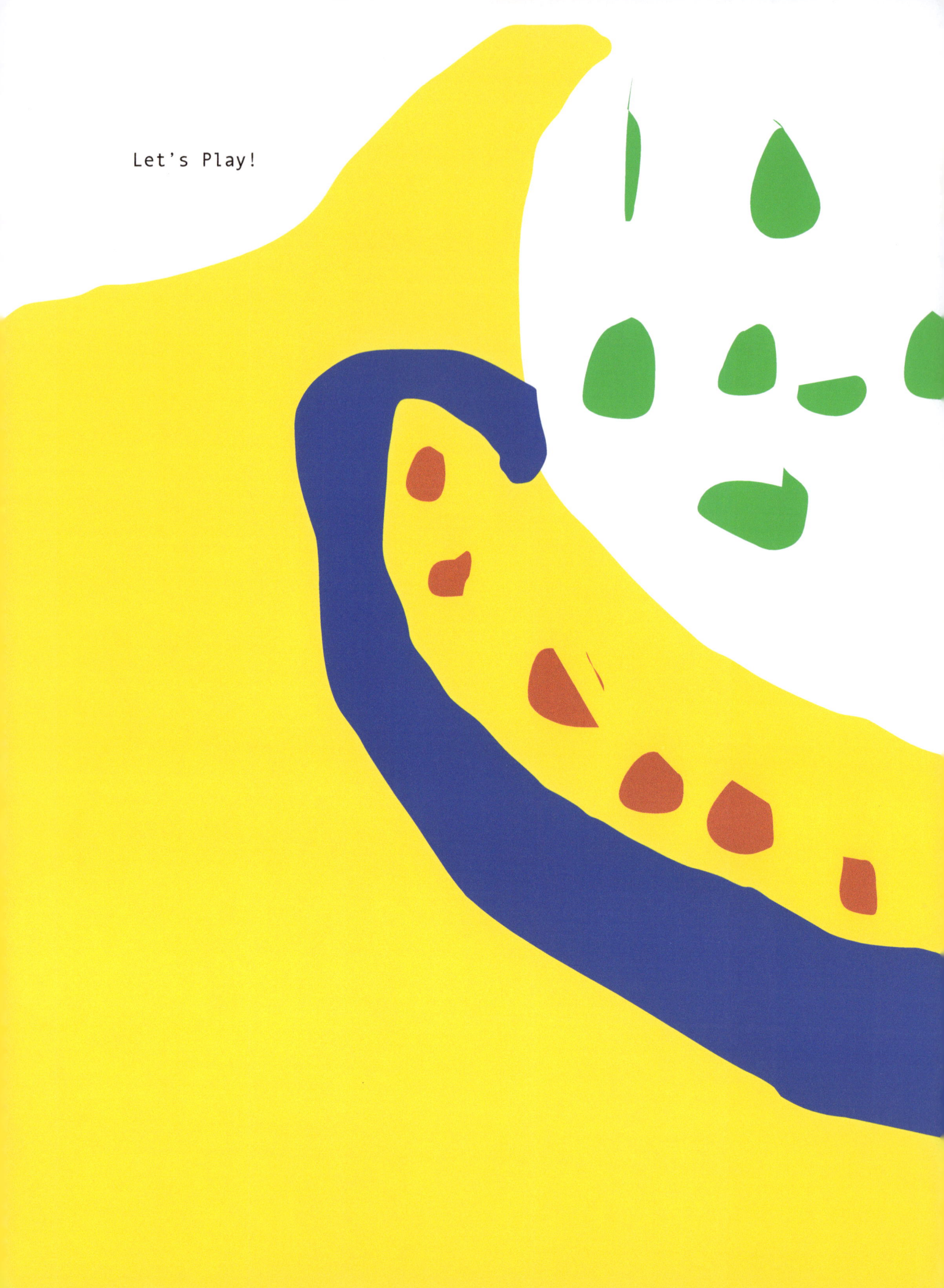

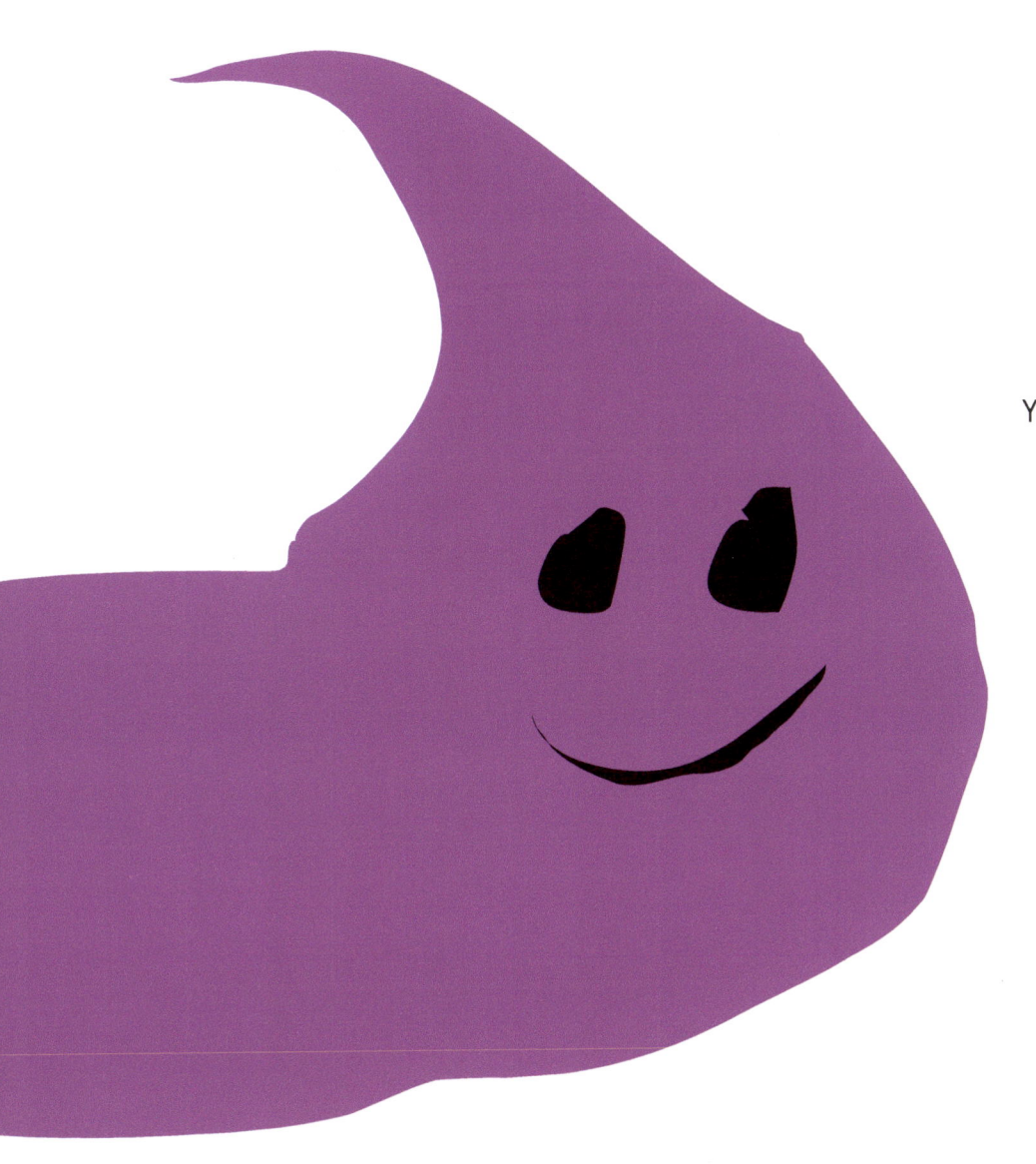

You look tasty!

www.ingramcontent.com/pod-product-compliance
Lightning Source LLC
Chambersburg PA
CBHW041303180526
45172CB00003B/951